Dear Fellow Artist,

Color has a direct and powerful influence on the emotions which is immediate and often affects us without our realization, yet its handling is too often a very hit and miss affair.

Careful study will provide a tool enabling you to alter perception, shape, and mood; to stimulate; or to provide tranquility. The discipline which is required for its understanding will be repaid as you learn to see color afresh and become more sensitive to its potential, handling it with increased confidence in your work.

Too many people attempt to put color to work without first educating themselves in its management. For the artist, the result is usually an unsatisfactory piece of work; the curiously abstract nature of color making it difficult to decide just what went wrong. A lack of knowledge and judgement can also lead to a piece of work that will cause irritation, tension, or even depression.

An artist relying only on intuition in his use of color chances many mistakes and the loss of the satisfaction and pleasure that a greater sensitivity to color brings.

One reason why color is so often treated as an incidental by artists and is frequently mishandled, might be difficulty in grasping its basic rules— in much the same way that many would-be musicians are put off by the seeming complexity of learning to read music.

In this book I hope that we will work together to learn how to read the "notes" and "scales" of our craft. There are few printed colors because I want you to find out slowly, and at first hand, the effects achievable. For the same reason, you will not find any complicated charts or diagrams. I believe that the only way to understand the optical effects brought about by various color combinations is to apply the pigments, observe, and make note.

When it is complete, the book will, I hope, add a new dimension to your work and your life.

Michael Wilcox

W9-CUX-285

Theory into practice

This book is intended as a guide to color harmony. While I cannot dwell, at length, on the area of color composition, I think it would be advantageous to take a moment to review the evolution of the effects we are studying, and their most successful practitioners.

The Old Masters are renowned for their use of transparent glazes, capturing reflections, and the rendering of deep mysterious shadows. Many of them used strong, vibrant colors in a very powerful way. Objects were painted as solid forms, with nature being called upon only for preliminary sketches.

During the 1880s, with the advent of the portable easel, artists started to leave their studios and work directly from nature, leaving behind, at the same time, many preconceived ideas on the nature of color. Previously, the belief had been that all objects had a "true" color, and little allowance was made for the influence of reflections from nearby objects. More importantly, by working in a studio, the artist was largely unaware of the effects that changes of light had on color.

This was the age of the Impressionists, who observed at first hand the fleeting colors of Nature and recorded what they actually saw. Of some influence also were the newly developed theories on the properties of light and color. Concerned by the muddying effect on color caused by mixing all three primaries on the palette, the Impressionists attempted to combine their colors optically by placing small patches of pure color side by side.

Determined to see all with a fresh eye, they looked again at shadows, which were usually painted in drab grays and browns. They realized that shadow was always the complementary color of the illuminating light: a scene bathed in warm yellow sunlight would throw shadows of violet and purple, these together with the reflections from nearby objects, interrelated with the actual colors present. By seeing and recording the color that is everywhere, their work sprang to life.

The Impressionists used the complementaries in a very skillful way. For example, in his landscapes, Corot often brought large areas of dull grayish green, such as trees and water, to life by adding a small amount of red, in a headscarf or other detail. These unobtrusive touches made his work so lively and interesting.

The method of mixing colors optically was possibly taken to its extreme by the Pointillists, who worked with small dots of juxtaposed pure color, the hue and position of which confirmed to very strict rules.

Although artists such as Seurat produced some very beautiful work with the Pointillist system, it was a drawback that the position of the viewer in relation to the painting was critical: too close and much of the effect was lost, too far back and many of the colors changed; the yellows tended toward white and the blues toward black, causing constantly changing optical mixes.

As soon as you can, study the original paintings, or prints taken from them, of the better known artists, from the Old Masters to the Impressionists, Pointillists, Abstractionalists, and the exponents of Pop Art. Nearly all of the various schools of art have used the theories that we shall study. When you are able to interpret the color arrangements that have been successfully used in the past by noted artists, not only will you be able to appreciate their skills, but as an artist in your own right, you will come to realize how vastly your repertoire can be increased.

Although many attempts have been made to formulate a rigid, logical theory of color application, all have had only a limited success. A universally accepted code of color arrangements has proved impossible to formulate. This I feel, is indeed fortunate, as it leaves us all free to manipulate color as we see fit.

The sections following will help you to understand color relationships in practice. When you have completed them, return to this chapter and discover how much clearer it has become.

What color is

To the Scientist:

colors are the components of light; without light, color does not exist. Newton established that sunlight contains all of the colors of the spectrum, which, as we shall discover, are either absorbed or reflected by any surface in its path.

We tend to think of the color of an object as absolute, that a red rose, for example, remains red even in the dark. This is not the case; the rose will only appear to be red in a certain light. Other types of light may change its color and without light it is colorless. Only illumination can create color.

To the Physiologist:

color is a sensation that reaches the brain via the eye. The eyes of the more advanced animals, including man, are able to receive the minute, constantly changing energy particles that comprise color, decode the information they contain, and pass it to the brain, where it is analyzed and the sensation of color registered in the mind.

Color can be likened to sound. Our brain, via the ear, can discern different *sound* frequencies as variations in *pitch*. Different light frequencies, registered via the eye, are experienced as different *colors*.

We know very little about the way the eye actually performs its task of receiving and coding the information. How the brain processes the stimulations passed to it by the eye is even less well understood.

The information passed from the retina is reorganized by the brain which decides just what it wishes to see. In many instances, our mind decides to perceive colors that do not exist. In experiments, images have been projected onto a screen with certain colors removed, which were nevertheless still seen clearly. As the images became more complex and started to represent recognizable objects, so more colors could be discerned, *which were not physically present.* We have a very poor memory when it comes to color; to save effort the mind often decides beforehand what the color of an object will be.

The brain also interferes further by dulling our awareness of the constantly changing colors brought about by subtle variations in the intensity of reflected light, enabling the colors perceived to remain steady and seemingly unchanging.

Vision is an accomplishment, not of the eye, but of the mind.

We will explore further influences of color on the brain in the chapter on simultaneous contrast.

Other animals see the same reflected light in quite another way. The cat, whose eyes are adapted to hunting at night, can only see color if its area is over a certain critical size. Dogs have poor color vision. Wave a red rag to a bull and it will look much like any other color to him—a shade of gray.

Some creatures are able to perceive color in a way quite impossible to us; certain birds and reptiles are able to filter out all but one color, on which they can then accurately focus. Many insects are able to see the ultraviolet reflected by certain flowers.

Although experiments show that different animals and insects can see certain colors, what we cannot be sure about is just how they see them.

A bird sensitive to red might see berries of that color in a different way than us. Exactly how its eye and brain respond to that red we cannot be sure.

Similarly, a flower we might think of as being a very bright, intense orange-red will probably appear dull to a worker bee able to see the ultraviolet being reflected by its center.

Even among ourselves, we cannot be sure that we see colors in the same way as each other. Color perception is so subjective as to be individual.

To the Artist:

color is a means of expression, and a very powerful means when fully understood. Since the early cave painters, color has been used to express the effects sought after by the artist. He has used it to give mood, shape, perspective, and harmony. The pigments that the artist uses consist of material that is able to absorb and reflect certain light wavelengths efficiently. Using paint, which physically is a powder mixed with a binder, the artist must understand fully the limitations as well as the potential, of color, before being able to use it with effect.

The Spectrum

The sun emits a wide variety of radiations which behave like waves that travel outward in all directions. Each is similar to a rope being shaken from one end.

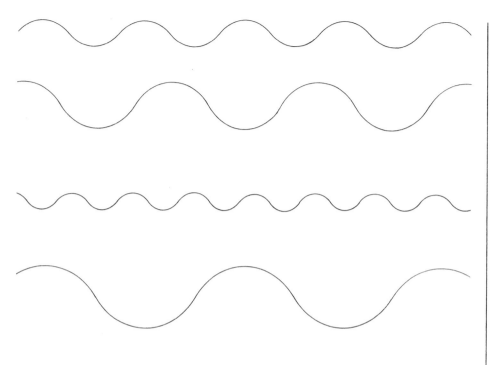

These waves, traveling in straight lines, reach the earth at incredible speeds. The distance between the tops of the waves is known as the wavelength. No two different wavelengths have the same motion.

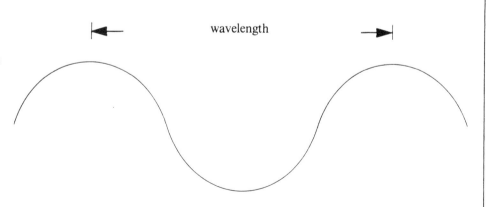

wavelength

Many of these radiations are prevented from reaching the earth by the atmosphere. Of those waves that do arrive, the more familiar will be the invisible x-rays and the ultraviolet and infrared radiations. Of more interest to us is the narrow band of wavelengths perceptible to the human eye which makes up visible light. I say the "human eye" because there are other light waves that we cannot see. Ultraviolet, for example, although very similar to the light wavelengths that we can see, is visible to many insects.

Let us now concentrate on the type of energy wavelengths we can see and which give us our illumination and, therefore, our colors.

The visible light that reaches us is made up of wavelengths that, although similar in character, vibrate at slightly different speeds or frequencies. Each light wavelength represents one particular color, and they all combine to reach us in the form of "white" light.

This white light is the natural light we call daylight. So natural light contains all the colors that we eventually see, but combined and travelling "as one;" they have to be broken down or decoded if they are not to remain as white light.

One way of separating the individual colors in this light that we are all familiar with is to pass the light through a prism. Let's see what happens.

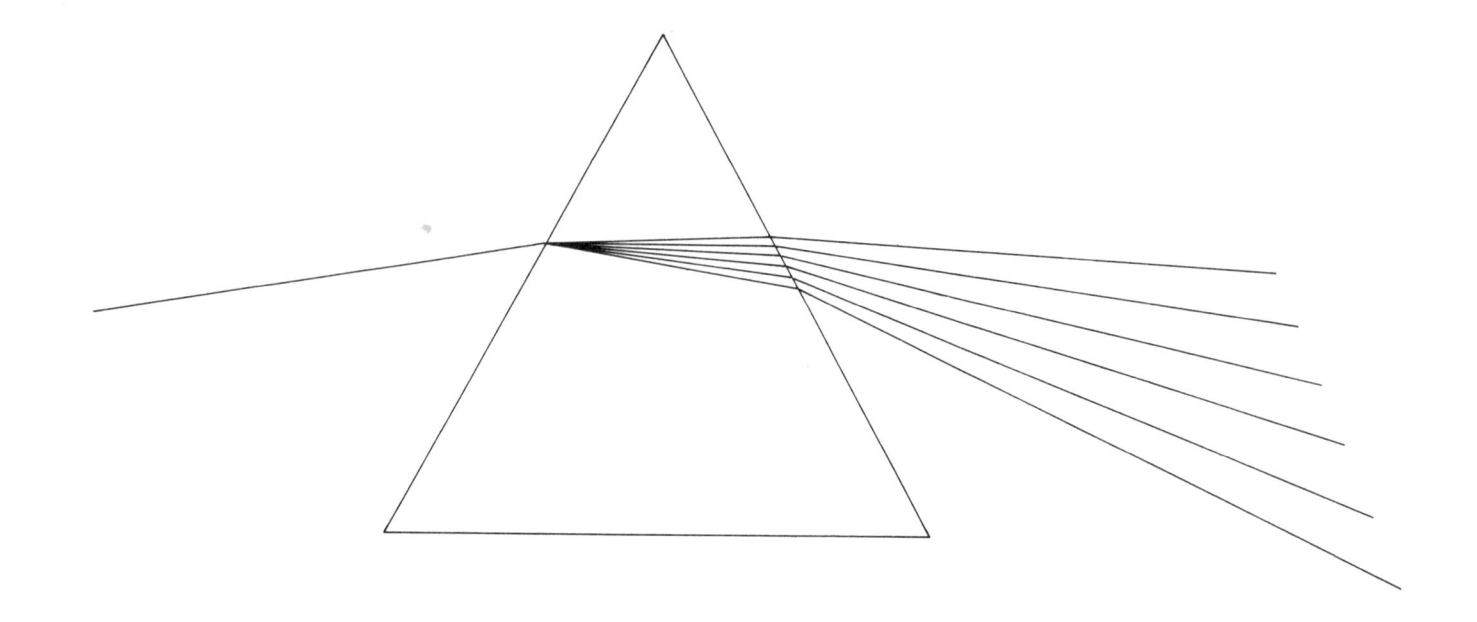

Our "color waves," remember, are not vibrating in step. They are all slightly out of phase with each other, but because they are combined and are all at the same spot at the same time, no wave dominates and together they form white light. When light strikes an angled surface, it is deflected slightly from its path. In the case of a glass prism, the light bends but continues its journey, each wavelength being refracted at a slightly different angle.

The waves that vibrate the most and have a short wavelength are also the most easily bent and are deflected more than the waves that vibrate slower and have the longer wavelength. Because the waves are being bent different amounts as they pass through the glass, they start to separate. As the waves leave the prism they pass again through an angled surface and are bent apart even more. They have now been separated from their travelling companions and are moving in different directions. The wavelengths, which are now separate, are still invisible to us, but if we put a white card in their path the full colors of the spectrum would be revealed. Let us take another look and, at the same time, find out the comparative wavelengths of the different colors.

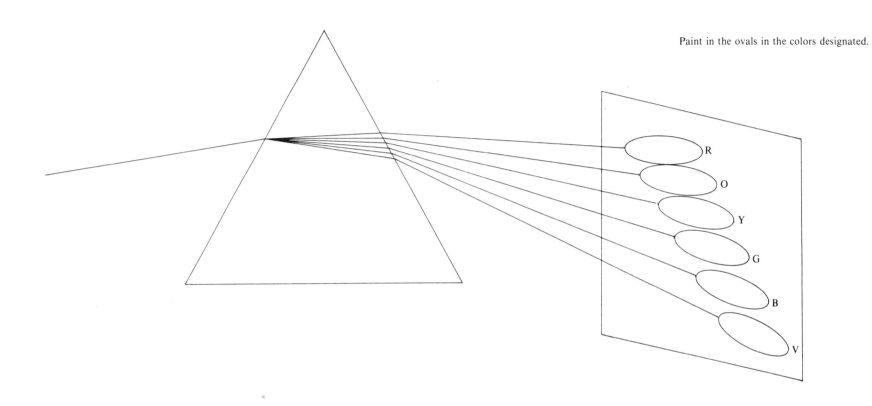

Paint in the ovals in the colors designated.

R
O
Y
G
B
V

For the sake of clarity, the colors are shown as though they were completely separated; in practice, some overlapping takes place.

As we can now see, the shorter wavelengths, which deviate the most, produce violet, and the longest and least deflected wavelengths visible to the eye, are red, with blue, green, yellow, and orange falling in between. Indigo, which was identified by Newton, is not now generally recognized as being a separate color.

We need to understand that light is comprised of different wavelengths that have to be separated and reflected in order to be seen. Now we shall discover what causes one surface to appear a different color from another.

Surface color

What happens when light, instead of passing through a prism, strikes a surface, depends on the molecular make-up of that surface. Light wavelengths are absorbed or reflected in varying amounts according to the nature of the reflector.

A white surface is so reflective that very nearly all of the "color waves" are reflected, and remain combined as white.

Some surfaces absorb nearly all colors and reflect very little. These become warm as the light waves are turned into heat and, as they do not reflect color, they appear black.

A yellow surface will absorb all of the visible light waves except yellow, which is rejected and reflected back from the surface to our eyes. As we can now only see the reflected yellow portion of the light, the object appears to be yellow. The other light waves are completely absorbed and turned into heat.

As the various heat wavelengths all arrive at the surface at the same time, the "yellow waves" will be reflected over the entire area. As a further example: if a surface appears blue it means that the other "color waves," the red, orange, yellow, green, and violet, will all be absorbed into the surface, and the "blue waves" reflected back to the eye.

It is not only single colors that are reflected; a yellow-green leaf will reflect both yellow and green wavelengths. The colors of the spectrum are reflected in various combinations producing the immense range of colors we see about us.

The Rainbow

We have seen, that if we take a conventional prism, we can split white light up into its component colors, but viewed from the side we cannot see these light wavelengths travelling. However, if we put a white card in their path they are reflected back as colors. Instead of the card, we can put our eye directly in the line of each wavelength and observe the color directly. Suppose we look at a prism at such an angle that only the "red wavelengths" are apparent; the other colors, though nearby, will not be visible— they are probably being reflected on our cheek. Now, if we move our head in relation to the prism, we will see each color, in turn, as it lines up with our eye.

Therefore, the color we see emerging from the prism depends on the angle formed between our eye and the direction of the light source.

If we were able to take our prism, enlarge it a great many times, and suspend it in the sky, the effect would be the same. Our light source would be the sun, its parallel light waves would enter our prism and be split into colors, and depending on our position on the ground, we would see one color or another.

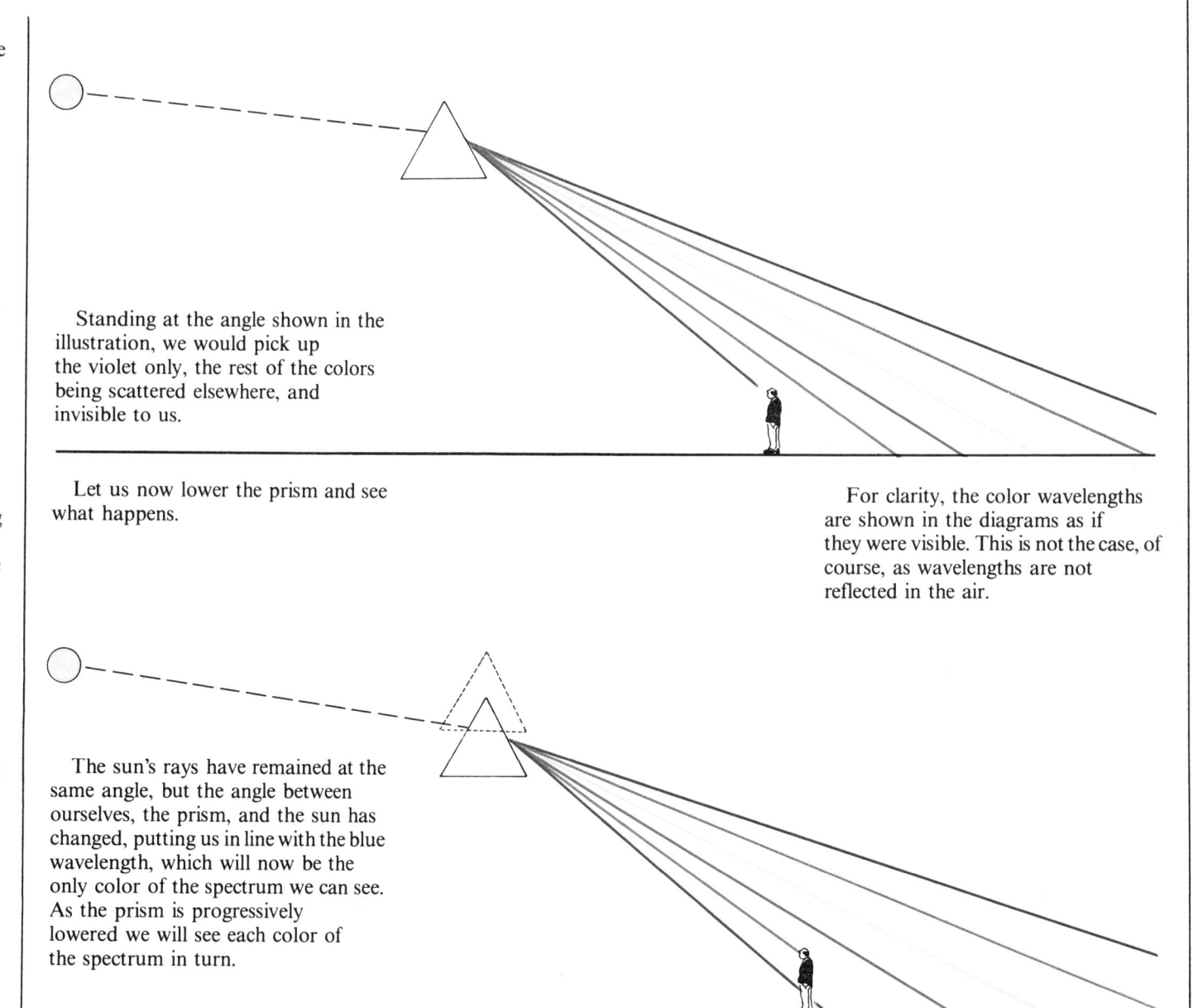

Standing at the angle shown in the illustration, we would pick up the violet only, the rest of the colors being scattered elsewhere, and invisible to us.

Let us now lower the prism and see what happens.

For clarity, the color wavelengths are shown in the diagrams as if they were visible. This is not the case, of course, as wavelengths are not reflected in the air.

The sun's rays have remained at the same angle, but the angle between ourselves, the prism, and the sun has changed, putting us in line with the blue wavelength, which will now be the only color of the spectrum we can see. As the prism is progressively lowered we will see each color of the spectrum in turn.

There are many clear, angled reflectors that are able to split light up into its colors: chandelier pendants, diamonds, even the edge of a piece of glass. But of interest to us is the simple raindrop.

Light entering our raindrop is split into its colors; it hits the opposite side of the raindrop already separated. The light is reflected back and

down to the bottom of the sphere where the colors are separated even further and will emerge travelling at different angles to each other. The raindrop acts in the same way as our prism.

We have seen that our prism, when lowered, will refract the colors one by one, depending on its position. The raindrop "prism" will do the same.

As the raindrop falls it will reflect one color after another—in rainbow order—to an observer on the ground.

One raindrop's reflections, of course, could not be seen, but the countless millions in a shower of rain amplify the colors so that we are able to see them.

You are probably ahead of me

at this point and have worked out the mechanics of an actual rainbow.

The raindrops at A will all be reflecting red, while those at B will show orange, and so on. As the drops fall they reflect different colors, but as they are constantly replaced, the effect is the same as having countless prisms suspended in the sky. Only those colors reflected at certain

critical angles will be visible to us. The colors which continue to be reflected by the falling raindrops will be scattered elsewhere.

The water particles that hang in the air after a shower can also give rise to a rainbow.

The effects of sunlight on color perception

As we have seen the color of an object depends on the molecular structure of the surface absorbing some colors and rejecting others. It therefore follows that the color we see must be contained within the illuminating light source.

When natural "white" light starts its journey from the sun, it contains all the colors we are able to perceive. But before it reaches us, it has to travel through the earth's atmosphere, which acts as a huge variable filter, changing the proportions of the colors to each other, and often eliminating some altogether. Similarly, artificial light often contains the full range of wavelengths which we may vary by using different colored filters.

The atmosphere is made up of molecules of various gases, chiefly oxygen, nitrogen, trace elements and dust to a depth of about 80 km (50 miles). These particles are mainly of a size to interfere with the blue and violet light waves, scattering them in all directions and causing the sky to appear blue. If these minute particles were not between us and the sun dispersing the blue and violet wavelengths, the sky would appear to be black since combined wavelengths are, as we have seen, invisible until split up and refracted. If, on the other

Midday

Early evening

hand, the molecules of the atmosphere were mainly of a different size and affected other wavelengths, we might very well have a red, yellow, or green sky, even with the sun overhead!

Of course, the sky does take on colors other than the bright blue of a cloudless day. Industrial areas and cities produce vast quantities of pollutants that rise into the atmosphere. The molecules of these additional gases and dusts are of varying sizes which act on all wavelengths and

therefore colors, including blue and violet.

So now we have all of the colors split up and scattered. They then recombine and form white light. This mixes with the blue being refracted by the "original" atmosphere and the result is the pale blue of our city skies. The most dramatic changes in the color of the sky occurs at sunrise and sunset. To explain these phenomena let us return to our midday blue sky.

The short blue wavelengths are scattered, while the longer, yellow, orange, and red light waves arrive almost unimpeded by the atmosphere.

When the sun begins to set, the light waves have further to travel through the gases and dusts of the atmosphere. This extra distance causes the short blue light waves to peter out as they become fully dispersed. The longer yellow wavelengths still reach us and are reradiated.

As the sun sets even further, increasing the distance the light has to travel, only the very long wavelengths reach us. These gradually tint the sky various strengths from orange to orange-red, giving us our beautiful sunsets.

As the sun rises the next morning, the whole operation is repeated in reverse: the longer orange-red wavelengths reach us first, gradually turning yellow, then blue. Sunrises are usually not as intense as sunsets; the damp air of the night having settled many of the particles in the air.

Clearly, the time of day will affect the composition of natural light, and therefore, the colors that we see about us. In the early morning the light is a pale, slightly chilly yellow. By midday we are surrounded by white light, carrying the colors in more even strength, without a bias towards any particular one. The colors that we see in light reflected from a cloudless northern sky at midday are as close as possible to our idea of their true values. This is the ideal light in which to paint.

Toward evening, as the short light waves deteriorate and the longer yellows and reds take over, we are bathed in a soft warm light and our perception of colors will be altered.

Another major factor in the makeup of natural light is the type and density of the cloud cover. The minute water particles that compose clouds act in the same way as the pollutants over our cities, refracting and dispersing all the wavelengths of color, which then reform

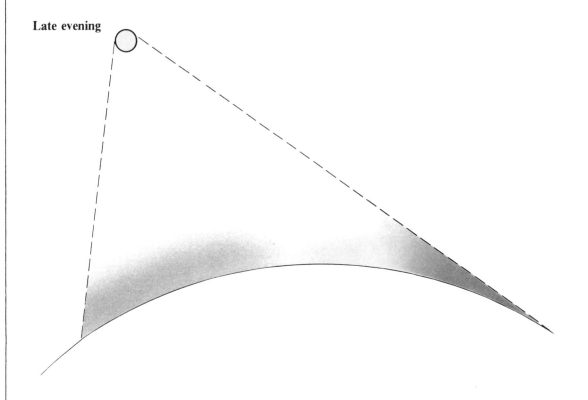

Late evening

into white light and cause the clouds to appear from white to dark gray, depending on their depth. From above they all appear white as the light is reflected back. This dispersing and reforming of color waves also causes the intense whiteness of surf.

All of the various factors that influence color: time of day, type

of cloud cover, atmospheric content, will make, say, a red tomato, take on a constantly changing hue; in fact, it never possesses a true color. Our eyes adapt to these changes all the time, so we hardly notice them. A series of color photographs of the same object taken at different times of the day will make the color variations immediately obvious.

We must beware of being too trusting of daylight when judging color.

The properties of color

The term used to describe the properties of color seem to cause a lot of confusion, but if the maximum benefit is to be obtained from art instruction books they need to be fully understood. Although there is a wide range of descriptive words, they are often used inaccurately. Of importance to us are the following:

Color

Everything that we can see has a color, regardless of how light or dark, bright or dull. Even black, white, and gray are considered colors, although without hue.

The word color is a very general term. The following descriptions, Hue, Saturation, Neutrals, Grays, Value, Tints, and Shades are more precise definitions.

We have now explored the visible light wavelengths, red, orange, yellow, green, blue, and violet. These wavelengths determine hue. In everyday language we would refer to them simply as colors. Spectrum red is a hue, so is green, blue, and all the others.

These spectrum colors, or hues, as we will now call them, are referred to when describing close or similar colors. Thus Cobalt Blue, Prussian Blue, and French Ultramarine are close in hue (all being blues). Cadmium Yellow and Lemon Yellow are similarly related in hue. When you read hue, think color, until you get the hang of it.

Complete these boxes to obtain just four of the countless close hues of red.

Saturation (or Intensity)

Instead of describing a hue as being very colorful, pure, or strong, we refer to its degree of saturation. The term came originally from the dyeing industry and was used to describe the relative strength of a color.

When determining the saturation of a hue we compare it with neutral gray. For example, a new pair of jeans is a very saturated blue, far removed from gray. As they fade with wear they slowly become a less intense blue (desaturated) and closer to gray.

Adding white to a hue will desaturate it. A vibrant saturated color such as Cadmium Red will become less saturated as white is added and it moves toward pink.

The saturation of a color can also be reduced by adding its complementary (which we shall study in a later chapter) which will cause it to become progressively gray. Black will also reduce the saturation of a color.

Add white progressively to the hue in box 1 to reduce its saturation.

Cadmium red	+1 part white	+2 parts white	+3 parts white

Neutrals

As a hue becomes low in saturation (approaching gray) it is classed as a neutral. In mixing, the ideal way to neutralize a color is to add its complementary. We will look at this later again.

Grays

Between almost total color absorption (black) and near total reflection (white), lie the grays. When the primary colors, red, yellow, and blue are mixed in more or less equal intensities, the result is a true neutral without color bias, which is classed as a gray.

Mixing complementaries will produce either a neutral color or a gray, and is the favored method in painting.

R	Alizarin Crimson	Cadmium Red	R-V

Value

The value of a color is determined by comparison with a scale of grays (ranging from white to black). The easiest way to visualize the value of a color is to imagine it as the shade of gray that would be registered if it were photographed in black and white. You can see a similar effect on a black and white television picture. Some colors have a wider range of values than others.

Red is basically dark in value; when it is lightened it becomes pink.

Yellow, on the other hand, is always relatively light in value. When it is darkened it becomes a muddy brown.

In order to determine the value of a hue, hold it against the gray scale.

Tints

When white is added to a color, the resulting mixture is referred to as a tint of that color. Tints are always lighter than the normal values of a hue. Referring back to the observations on values, you will remember that red is always relatively dark in value because the addition of white changes it to pink. Therefore pink is a tint of red. In everyday language, if one color affects another we often refer to the main color as being tinted. For example, we might say "blue with a green tint."

Shades

Shades, on the other hand, are always darker than the normal values of a color (dark blue, deep red).

In common usage a shade refers to a color that differs slightly from a named color (e.g. a shade of green).

A more scientific approach to producing shades would be to mix black with a color, but this is a practice usually avoided by artists as it can only lead to "dirty" and unattractive colors.

Paint the top half of the boxes in the specified hue—add white to each and paint in the lower part to show the relationship of a color to its tint.

Yellow Ochre

Cerulean

Cadmium Orange

French Ultramarine

Add a little French Ultramarine to Cobalt Violet to darken it.

A touch of darker Cadmium Yellow Pale to Lemon Yellow.

Darken Cobalt Blue with a little French Ultramarine.

Cadmium Red with a little of the darker Alizarin Crimson.

The Primary Colors

The primaries are a "set" of three colors which, mixed either optically or materially in varying proportions, will give almost every other color. But no two mixed together will produce the third.

The artist's primary colors are RED, YELLOW, and BLUE, and are known as the "subtractive" primaries. There is another set of primary colors, those of light, which are RED, GREEN, and BLUE, known as the additive primaries.

Do not worry about these terms as we will explore our two sets of primaries in greater depth.

You may have come across reference to a set of four primaries, RED, YELLOW, BLUE, and GREEN. These are known as the psychological primaries and appear to be quite unlike each other visually. We need not concern ourselves with them here.

Additive mixing — the light primaries

Light, as we have discovered, can be split up into its various colors and then recombined into light. Two examples, seen earlier, were clouds and surf, which both cause lightwaves to refract and disperse.

White light can also be produced by mixing just three of the spectrum colors in light form. If we project red, green, and blue light beams of equal intensity onto a white screen they will combine into white light.

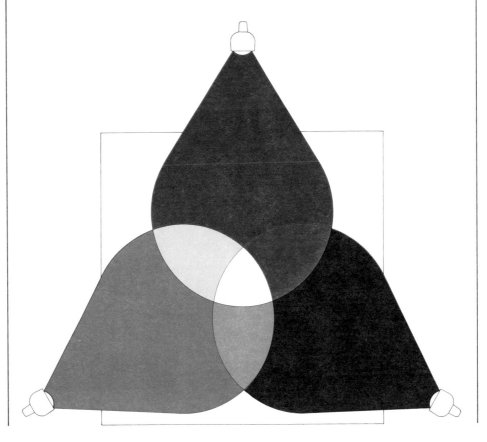

Mixed in other proportions of two or all three together, almost any other color can be produced.

In light form, these three hues are known as the additive primaries.

In this illustration the additive primaries are shown overlapping; where all three do so (if they are of equal intensity), white light appears.

Red and green light, surprisingly, produces yellow; green and blue will form cyan (greenish blue), and blue and red will make magenta (bluish red). These "by product" colors, yellow, cyan, and magenta are known as the secondaries.

In additive mixing, secondary colors are always brighter than either of the primaries that contribute to them. This might seem strange as one would expect a mixture of, say, red and green to produce a darker color; remember, though, that we are still working in colored light. As all three primaries mix to produce white light, so any two will combine to form a color representing two-thirds of the white light. When we mix color in light form, brightness is always added. As we will find out, it is quite a different proposition when we mix colors as pigments.

The artist's use of color: subtractive mixing

Although it is important that we have an understanding of additive mixing, even if only to save confusion when we come across reference to it, we do not need to go into it in any great depth, as it is really the province of the photographer and the printer. As artists we must concentrate on, and understand, the potential of our own set of primaries; the more familiar red, yellow, and blue, the combinations of which are known as subtractive mixing.

We know that colored light beams when mixed become even brighter, but when pigments are mixed the results are quite the opposite.

The secondary colors that result, orange, violet, and green, are now darker than the lightest contributing color used to mix them: orange and green being darker than the yellow, and violet being darker than its red.

If we take red, yellow, and blue as opposed to magenta, yellow, and cyan, the secondary colors of additive mixing, and mix them in equal intensities, we produce, not the white of our colored lights, but a very dark gray.

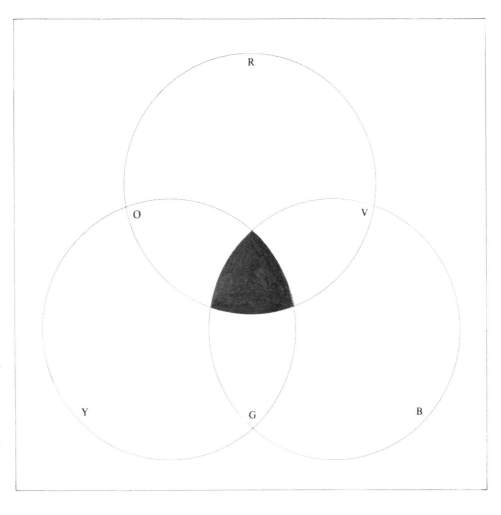

What is the reason for this loss of light when we mix pigments, as opposed to the gain when mixing light?

Paint, like any colored surface, will reflect certain color waves and absorb others; it is the absorption of light that causes the colors to become degraded in brightness.

When the three subtractive primaries are mixed in equal intensities only one-third of the light energy reaching the surface is reflected, the rest is absorbed. The result will be a dark gray.

The knowledge that the primaries move toward gray when all three are combined will help us to understand the effects of complementary color mixing which we shall study later.

Whenever substances that reflect light—such as artists' paints or printers' inks—are combined, subtractive mixing will occur.

Pigment color bias

As we have discovered, when pigments are mixed light is absorbed causing the secondary colors, orange, violet, and green to lose intensity.

A further problem involved in obtaining pure secondary colors is the unfortunate fact that it is impossible to obtain true primaries in pigment form.

For a primary hue to be considered pure, it should not contain any trace whatsoever of the other two primaries.

Of all the pigments available to the artist there are no exact equivalents to the red, yellow, or blue of the spectrum. This of course is a great pity; if the artist could obtain his primary colors in pure form, he would only ever need these three.

For the purpose of this book, I suggest that you use the following as your primary colors.

YELLOW:
Cadmium Yellow Pale; close to being a true yellow, although it does contain a little red. It mixes well into the oranges, but dulls the greens, which is the reason I have suggested cool, bluish Lemon Yellow in the yellow-green mix.

BLUE:
Cobalt Blue; leans only very slightly toward yellow and almost satisfies the definition of a primary hue. French Ultramarine, containing red, mixes a little better into the violets.

RED:
Alizarin Crimson; slightly bluish but close to true red. As its blue content will dull orange mixes, it is best replaced by Cadmium Red to produce a pure orange-red (O-R).

ALTERNATIVES:
Rose Madder Genuine and certain reds and magentas are closer than Alizarin Crimson to true red, but like most alternatives to the pigments that I suggest, are often very expensive, weak in mixtures, or prone to fading. By all means, use one of them if you wish.

If using other pigments, first decide on their color bias and make a few experimental mixes. To illustrate the problems that can occur when unsuitable primaries are selected to mix a secondary or tertiary color, try combining Cadmium Red with either of the blues; the result will be far removed from Violet.

To avoid problems in obtaining the intense, pure secondary colors required for the diagrams, I suggest that you use the following:

ORANGE:
Cadmium Orange; a very bright, pure, true orange that cannot be mixed quite so vividly from any combination of yellow and red.

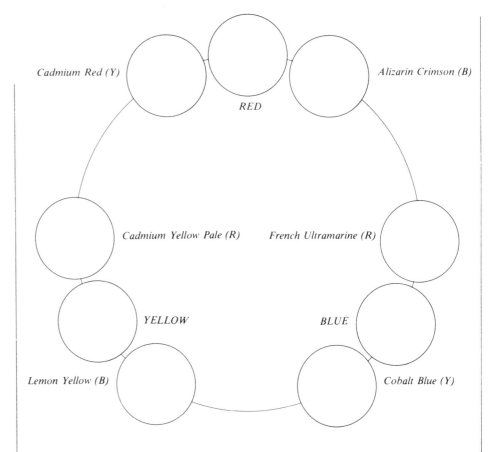

GREEN:
Viridian; slightly bluish, but contains no red whatsoever. A very pure, intense, transparent green.

VIOLET:
Cobalt Violet; a pure, clean color. Some makes tend to be on the red side and need the addition of a little French Ultramarine.

An almost pure violet can be obtained by mixing Alizarin Crimson and French Ultramarine. Both tend toward red-blue and do not contain any yellow.

Either mix your violet using these colors, or use Cobalt Violet.

As this is not the place to become over-involved in color mixing as such, if you wish to explore your palette's range further, may I suggest my book *Color Mixing System*.

The Color Wheel

The color wheel will provide us with an optical interpretation of the properties of color. From it we can identify the warm and cool colors and also match up the complementaries.

The colors in the wheel are arranged in the order in which they appear in the spectrum, with red and violet (the high and low ends) adjacent, and joined by their mixture, Red-Violet.

First complete the primaries (which cannot be mixed from other colors) red, yellow, and blue.

As outlined on the previous page, there are certain problems involved in mixing a pure secondary color. For this reason, paint in the secondaries following the instructions inside the front cover.

The tertiary colors, orange-red, yellow-orange, yellow-green, blue-green, violet blue, and red-violet are completed next, also following the coloring instructions. If you wish to complete the wheel, be careful to use the correct primaries in the mixes as outlined on page 23. For example, the color between yellow and yellow-green would be a mix of Lemon Yellow and a little Viridian.

When finished, the wheel will provide a nearly continuous transition of color; the rainbow in circular form.

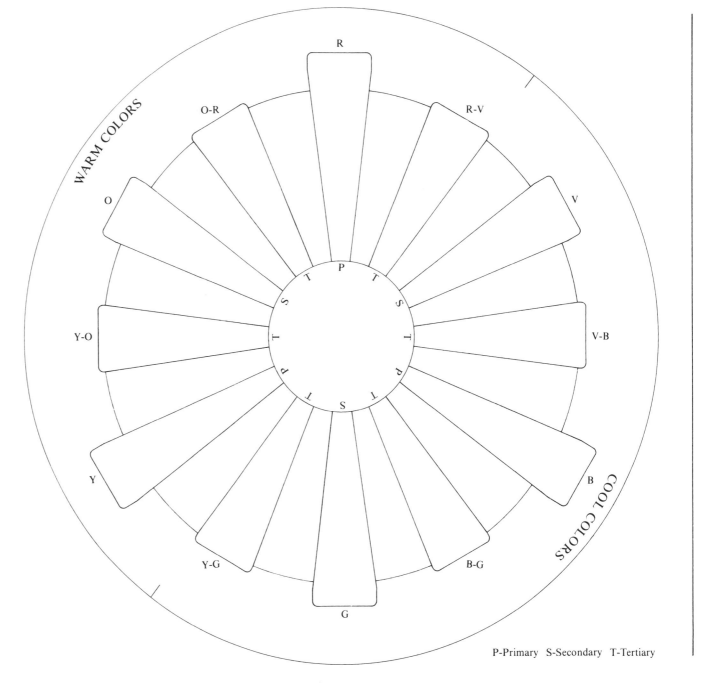

P-Primary S-Secondary T-Tertiary

Colored neutrals

The primaries, and any mix containing two of them, are known as pure colors, so all of the hues in the wheel that you have just completed will be pure (within the constraints outlined on page 23).

As soon as the third primary is introduced to a pure mix, a duller, impure color is created, which, depending on the proportions used, is described as being either a colored neutral or a gray.

Referring back to the notes on the meaning of the terms saturation and neutrals, you will remember that "as a color becomes low in saturation (approaches gray) it is classed as a neutral." We can reduce the saturation of a color by adding white, as we did in the exercise, adding black (which as an artist, I hope you will never do as it can only deaden and dirty your colors), or by mixing in the third primary to a pure color mix. Let us produce a few neutral colors by mixing the three primaries.

1. Mix blue and red* in equal amounts to produce violet, a pure color as it comes from only two primaries. Then add a little yellow (the third primary) to produce a warm colored neutral.

2. Produce a green by mixing yellow and blue, then add a touch of the third primary, red. The result will be a cooler neutral.

3. Now mix yellow and red to produce a pure orange, add a small amount of blue, and the result will be a colored, fairly warm neutral.

*Use Alizarin Crimson and French Ultramarine for your red and blue as they will produce the purest mixed violet of the palette.

Mix all three colors on the palette and paint in the center circle. The outer circle is segmented into the primaries to give an instant indication of the hues and proportions mixed in the center.

1

2

3

For your experiments, pick any two of the primaries, mix them in whatever proportions you wish and add the third primary. Make a note above the circles of the colors you use; the range is almost limitless.

The proportions of the third, or indeed any of the primaries, are unimportant; the result will always be a colored neutral, provided the proportions are unequal.

Grays

In the chapter on surface color, we learned that when nearly all of the spectral wavelengths (colors) are reflected from a surface it will appear white, and when they are mostly absorbed, it will be black. Between these two extremes lies a wide range of grays. When the three subtractive primaries are mixed in equal intensities, only one-third of the light energy reaching the surface is reflected, the rest being absorbed. The result will be a dark gray.

By mixing the three primaries in more or less equal amounts, we can produce a range of true neutrals: the grays.

We can vary the results by using different pigments, for example, the red in a gray can be Cadmium Red, Vermillion, or Alizarin Crimson.

Let us mix one such gray:

Combine the red, yellow, and blue that we have been using as our primaries, in as near as possible equal amounts.

Thin a portion of the mix near its edge to see if one, or even two, of the primaries are predominating; if they are, add small amounts of the color or colors being swamped, until you have a perfectly normal gray.

Paint in the center of the first diagram, then add one of the primaries to this neutral gray to produce another colored neutral. Now paint in the second circle.

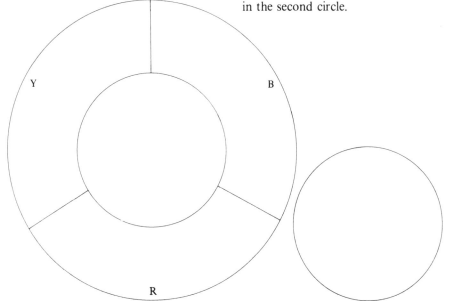

The Complementary Colors

Complementaries are hues that lie diametrically opposite each other on the color wheel.

The effects that complementary colors have on each other, both optically and in mixes, are of crucial importance in all uses of color sensation, but particularly for the artist.

Skillful use of the complementary hues will add subtlety, interest, and life to a painting, and is so very often the difference between success and failure.

We know that in subtractive mixing the three primaries, when combined in equal intensities, absorb so much light energy or color wavelengths that they appear as a very dark gray. However, if we mix them in unequal proportions, as we did during our study of neutral hues (two primaries with the third added), a wide range of colored neutrals can be produced.

If you refer to the examples of mixing colored neutrals on page 27 and check with the color wheel you will see that you did, in fact, mix direct complementaries, violet + yellow, green + red, and orange + blue. In these mixes only a small amount of the second complementary was added and the neutral hues had a definite color leaning. Colored neutrals can be produced from a mix of any pair of complementaries.

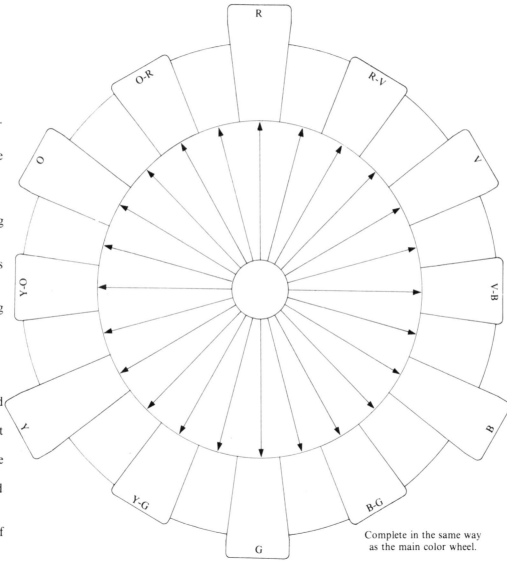

Complete in the same way as the main color wheel.

When the complementaries were mixed in near equal intensities a true neutral, a gray without color bias, resulted.

If, instead of combining any of the pairs of complementaries physically on the palette, we mix them optically by placing them side by side, the eye will try to combine them into gray. Because it cannot do so, each will appear to become brighter and more vibrant, the more so as they move optically from colored neutrals (unequal complementaries, one weaker than the other) to gray complementaries equal in intensity.

The eye will become stimulated the more any two colors approach a complementary relationship.

For maximum contrast, complementaries should lie in the same temperature scale. (See chapter on warm and cool colors, page 57.) Thus, warm colors to warm and cool to cool; a warm blue against a warm orange; cool Lemon Yellow opposite cool pink, violet, etc.

Of course, the color wheel will only give an indication of color temperature. So many different warm and cool colors can be mixed that they must be paired carefully.

Let us look at a few examples of juxtaposed complementaries.

You will see that the color pairs in this exercise, painted at full strength and covering equal areas, will appear harsh and unharmonious, but will contrast vividly.

Refer back to the main color wheel and you will see that there are a great many permutations of complementaries.

The reasons for the optical effects of this phenomenon will become clearer in the next chapter, "Simultaneous Contrast."

Paint fully saturated.

The Bathers by Seurat is often mistakenly thought of as being painted in the Pointillist technique, whereas, Seurat actually used the broad flat brush strokes of the Impressionists. His colors were mixed first on the palette, as opposed to the optical mixing of his later work.

Note the intense luminosity of the scene and the liveliness of the details, even in the shadows. This effect was achieved by his very intelligent use of complimentary color pairs.

How many examples of juxtaposed, close, or actual complementaries can you spot? Two of the more obvious would be the orange hat and trunks of the boy in the river against the blue of the water, and the hatband with touches of violet at center against the yellow.

Light is also introduced into the painting by the skillful use of very small touches of complementary colors in the dull reds in the grass, such as the violets and yellows in the bank, the buildings, the bathers' clothes, and even in their skin tones. This method of adding light is particularly effective in the colors of the water, especially below the boy in the hat.

Although the use of complementary color pairs can give light and vitality to a painting, they have to be handled with great care. Used too strongly or indiscreetly, the result can be harsh and unsettling.

Seurat "worked" his colors carefully to avoid clashes. White was added to some hues, others were darkened, colors were intermingled, light and shadow were carefully balanced.

To appreciate the planning that went into this painting, imagine any of the colors being different from what they are. If the hat and trunks of the boy in the river were any other color, the water would not appear so blue, and vice versa. Mentally change any of the colors or their values and you will see how carefully they were organized.

Georges Seurat: The Bathers, Asnières.

The National Gallery, London

Complementaries against a neutral background

As we have seen, complementary hues placed side by side give the greatest possible contrast, but when used fully saturated they do not harmonize and are unpleasant to the eye.

In order to make full use of their properties of contrast, the complementaries must be carefully manipulated.

One way to use them to great effect is to introduce a small area of highly saturated color into a large area of its neutralized complementary.

This technique was a particular favorite of Corot, who accentuated small areas of bright red detail, such as a hat or scarf, against a large area of dull, neutralized green.

As long as the area of the saturated color is kept within limits and does not become overwhelming, this combination will add visual excitement to a painting.

Many colored neutrals, when mixed, are discarded as being "muddy," but if their complementary is found and used in this way, some very interesting effects can be achieved.

Paint the ovals with a fully saturated red. Mix the smallest touch of this red with Viridian and complete the diagram with this quieter green. Apply the paint thinly.

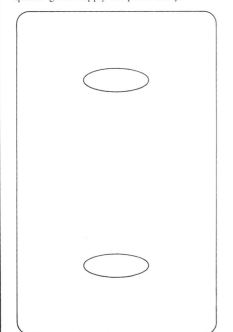

Color the smaller areas with a highly saturated yellow. For the neutral background mix a tiny amount of yellow with Cobalt Violet and apply lightly.

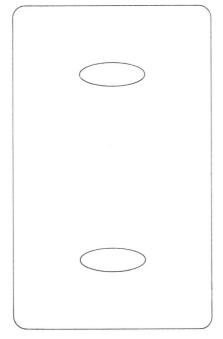

Cobalt Blue at full strength, surrounded by Cadmium Orange neutralized with a little of the blue.

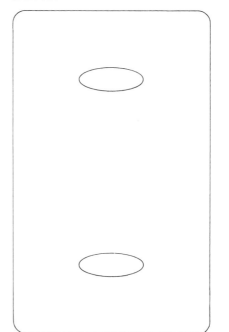

Paint the small areas with undiluted Cadmium Orange, cool its complementary, Cobalt Blue, with a tiny amount of the Orange, and lightly color the background.

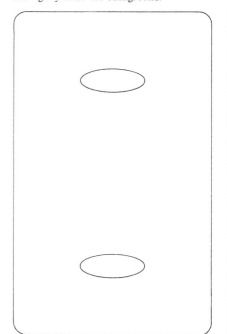

Tinted complementaries

Another and very versatile way of moderating the complementaries is to lighten them considerably.

The tints of a complementary pair, if low enough in value (desaturated), will not clash, even when both cover a large area. The Monet print on the following page illustrates the effective use of this technique.

R + W

G + W

Y + W

V + W

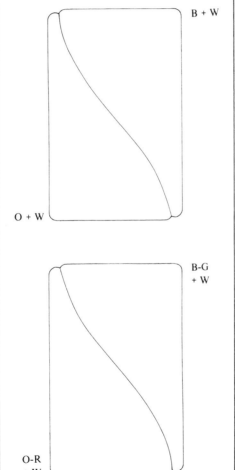

B + W

O + W

B-G + W

O-R + W

Darkened complementaries

Darkening a hue will also desaturate it. The diminishing of contrast as complementary colors are darkened will make them more harmonious.

It is preferable to mix colored darks rather than to add black, which can only dull and dirty your colors.

Mix a dark violet from Crimson Alizarin and French Ultramarine for the first half of a box. Add a darker yellow, such as Yellow Ochre, to the second half.

For the rest of the exercise, decide on your complementary color pairs and, either mix darker hues, or select them from your palette—dark greens, blues, red-browns, etc. Any color, however dark, can be matched against its darkened complementary.

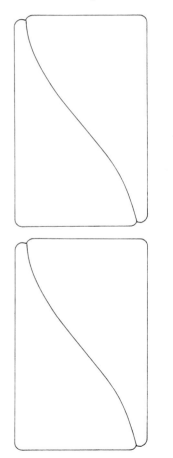

In this painting Monet used complementary color pairs to add light to the scene.

As the blues of the snow and the orange of the hills cover such a large area, they both had to be calmed down considerably by adding white. The color in the hills is further moderated by intermingling dashes of blue and violet.

Similarly, the violet and red-violets in the hills add luminosity to the lighter yellows in the sky.

Although not shown directly, the sun is the main element in the painting.

There are many examples of desaturated complementaries in this work. As you look for them, and as you study other great paintings, you will begin to realize that the color combinations did not result by happy coincidence. The colors used by the Masters were very carefully planned before work started. Successful accidents of color (far from being relied upon as is so often the case nowadays) were rare.

Before you start your next piece of work, think very carefully about the overall effect you are seeking and plan your color combinations before you start. I feel that too much emphasis today is placed on the "shapes" involved in the composition of a painting. Get the color balance right and you will be ninety percent of the way to harmonious, pleasing work.

Claude-Oscar Monet: Winter, Lavacourt (?).

The National Gallery, London

Simultaneous contrast

First, we must briefly sum up the ground we have covered so far.

We now know that the commonly held concept that all things possess their own fixed color, which is retained even in the dark, is not the case. It is the selective absorption and reflection of colors in lightwaves which gives objects the appearance of color. We have seen that these lightwaves must reach the brain via the eye to be perceived as colors.

Of all people, the artist must be aware of the fact that the light source, be it natural or artificial, will, depending on its visible light wave content, determine the color of all we see. We must also remember when working in natural light, that colors will change with the time of day and the weather conditions.

The next, and for the artist probably the most important factor in determining the colors we perceive, comes under the grand title of *simultaneous contrast*. The term is nothing to worry about; it simply means that all colors are affected directly by the color placed alongside them—as we already discovered with our pairs of complementary colors.

Simultaneous contrast is an optical effect that we can explore stage by stage.

First paint the oval on the left red.

R

Paint fully saturated.

When completed, stare at it fixedly for about 30 seconds, then transfer your gaze to the empty oval on the right. You will find that the "after image" from the first oval has colored the second one green, the complementary color of red. If you close your eyes the effect will still be present. What has happened is that the receptors in the eye that receive and transmit red signals to the brain have become dulled from the strong exposure to red, but the green receptors, having had nothing to do (as the green waves are far removed from the red) are fully rested. When both red and green systems focus on the white area, the green takes over and an image is formed. For our purposes, how it happens is not as important as the fact that it does.

43

R

G

Now paint in both the left hand and the right; the oval on the left is again red with the right one green. Cover the red with your hand and note the intensity, or *saturation*, as we should say, of the green. Now cover the green and concentrate on the red for about half a minute. Looking again at the green oval, you should observe a quite definite strengthening of the green where the after-image overlaps; it will appear to be brighter than before. To understand the reason for this extra intensity of color, think back to the first part of this experiment; the green after-image that we transposed to the right hand oval now rests on green paint instead of white paper, and the two "greens" combine to produce one stronger green with added light. The effect can be compared with painting a wall; the second coat will increase the intensity of color.

The after-image will gradually wear away as the red receptors in the eye overcome their "fatigue" and join in. The green will slowly return to its former strength.

Try the experiment the other way around, looking first at the green for a while and then at white paper. What do you see? There is an after-image of red as the effect is reversed. This after-image will, of course, strengthen the red in the center of the other oval when you look at it.

This effect is not confined to red and green alone. Let us look at the after-images associated with a few other colors.

Paint in the shapes. Look fixedly for a short time at the blank circle between each pair of colors, then move your gaze to the white area below. As the after-image registers, make a note of it on the line.

When you complete, you will notice that you have a list of complementary color pairs: the color of the shape and its after-image.

It will be better to describe the color of the after-image, "a light blue tinged with green," for example, than to try and use a pigment name. Unmixed manufacturers colors are not easily matched into complementary pairs.

Although the colors that I have suggested for the complementary wheel are close to being pairs, much will depend on the make of paints that you use.

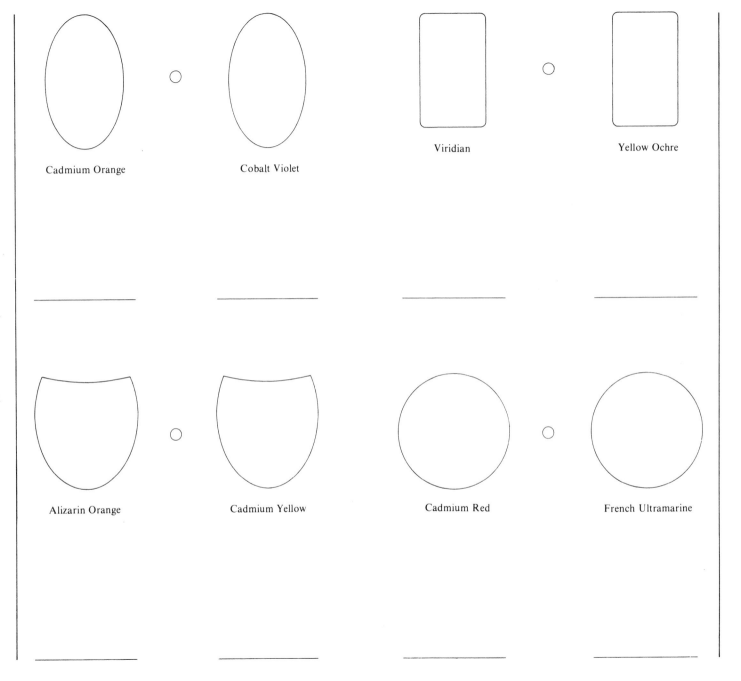

Cadmium Orange Cobalt Violet Viridian Yellow Ochre

Alizarin Orange Cadmium Yellow Cadmium Red French Ultramarine

Going back to the green after-image that resulted from the red, we recall that when we looked at a green, the result was a stronger green. Let us see what effect our optical trick will have on a color other than green.

As in our earlier experiments, impose the after-image from the red onto the yellow. As you are probably now expecting, where the after-image strikes the yellow, a yellowy-green results; in reverse the violet after-image from the yellow will affect the red. (The complementaries of red being green and yellow being violet.)

The eye will retain many after-images at the same time. Paint these diagrams in the colors of your choice, impose the after-images from either, firstly onto white paper and then onto its neighbor.

The after-image effect of colors viewed, as we have been doing, in isolation, is known as *successive color contrast.*

When colors are side by side, as in a painting, they will continue to influence our judgement. This phenomenon of color change, whenever two or more colors are present in the *same visual field,* is known as *simultaneous contrast.*

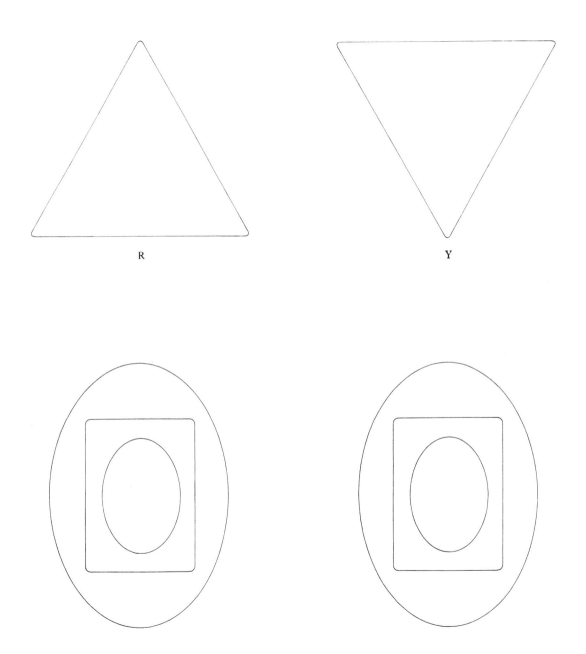

Simultaneous contrast exercises

In the first exercise, the after-image of the color in the outer box will cause the yellow centers to appear stronger in the first box, tinted with turquoise in the second, and green in the third.

Here the green centers will be tinged with yellow, violet, and bluish-green, respectively.

The gray center will appear gray-green next to the red, reddish-gray with the green, and turquoise within the orange of the last box.

In the final part of the exercise, carry out your own experiments with whatever colors you wish for both the inner and outer boxes. Make a note under the box of the influences the outer color has on the inner.

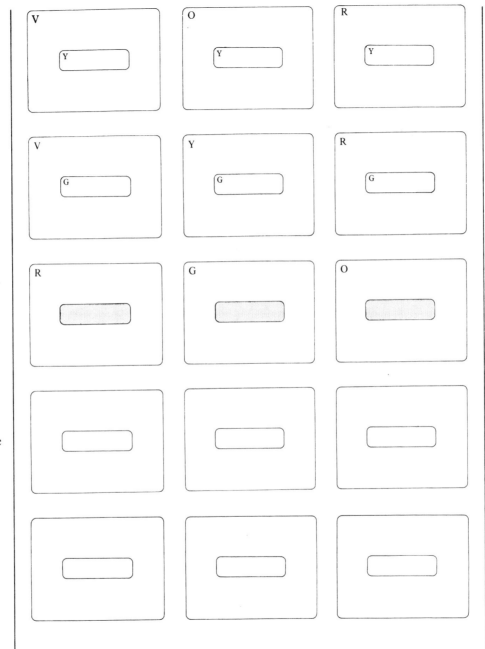

To sum up: the after-image, which is a color that seems to float in front of our eyes after they have been stimulated by its complementary, will influence any other colors in the same visual field. The effect is strongest when complementary hues are adjacent, but the after-image of any color will affect its neighbors.

The importance of these color influences to you, as an artist, should now be apparent.

Careful use of the complementaries, and an understanding of the effects of simulataneous contrast will with practice, lead you toward color harmony and well balanced, pleasing work.

51

Border contrast

Paint section **1** in any fully saturated color you wish, then lighten this hue and paint in section **2**, make **3** lighter still, and **4** very pale. Apply the paint as evenly as possible.

When finished you will notice that the color of any one of the bands will look lighter along the border with its dark neighbor and darker along the edge with its lighter neighbor.

The longer you look, the stronger will be the effect.

In this part of the exercise, paint the bands in varying colors. As long as there is a definite difference in the value (dark to light) of the colors, the effect will be the same.

This optical trick can be used to great effect in order to emphasize a particular shape.

Vibrating Color

When you have completed the exercise below you will notice that an aggressive flicker or vibration is set up between the colors. This optical activity will also occur with certain other color pairs, most noticeably red and green, and bluish-green and orange. Both colors must be fully saturated, close in value, and near or actual complementaries. The reason why flicker or color vibration occurs is not fully understood.

This optical phenomenon should be avoided unless you are really determined to attract attention to your work!

CR-Cadmium Red
C-Cerulean

Paint colors *fully* saturated—do not dilute.

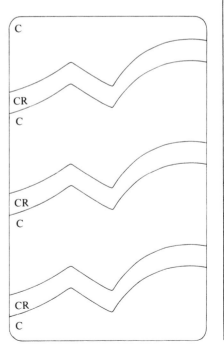

Two-color harmony

As we have seen, the careful use of complementaries can add vitality and light to a painting. The exercise on page 37 showed us how a small patch of saturated color against a larger area of its desaturated complementary had an immediate visual impact.

When painting quieter stretches it is often difficult to decide on colors that will "go with" each other.

By gradually adding a dark hue to one lighter in value, a scale of harmonizing colors will result.

The colors produced are not always predictable. When mixing direct complementaries in order to obtain a colored neutral (e.g. blue saturated with a little orange), a point can be reached where the two hues neutralize each other with a resultant loss of color. In most instances, though, the method of adding dark to light to arrive at a range of harmonizing colors works very well.

You can produce not only harmonizing neutrals in this way, but also the pure secondary colors: greens, oranges, violets.

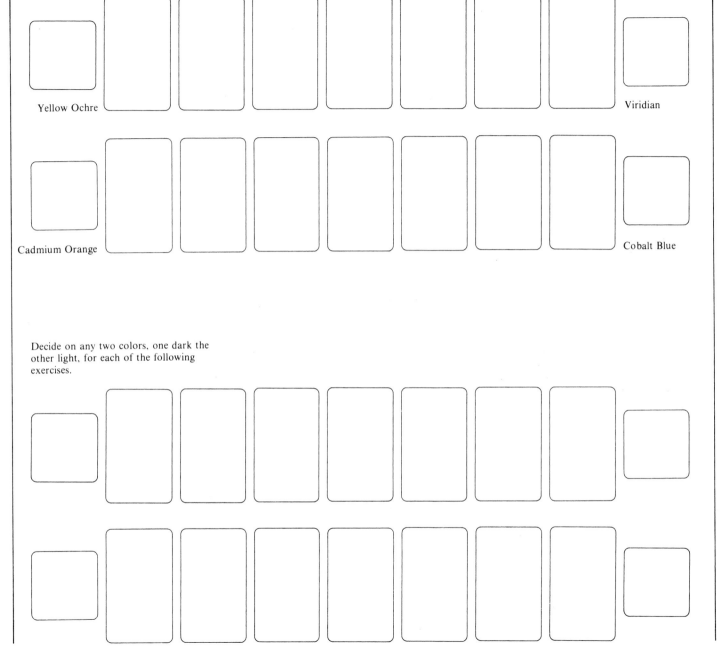

Yellow Ochre

Viridian

Cadmium Orange

Cobalt Blue

Decide on any two colors, one dark the other light, for each of the following exercises.

Optical mixing

Small dots or patches of color placed side by side will blend optically into a mix; this is the basis of color printing. Look at the printed colors in this book through a magnifying glass and you will see that they are composed of small dots of color.

The Pointillists covered their canvases with small dots of pure color, which blended at a distance.

If, in your work, you place small amounts of color side by side, from a distance they will mix together in the eye. This should be borne in mind as unintentional mixes can occur.

The warm and cool colors

You will have noticed that the color wheel you completed was divided into warm and cool color ranges. The warmer colors, the reds, yellows, and oranges of fire, seem to come forward and cheer the observer, while the blues of ice and snow recede, and have a cool appearance. Dividing the color wheel up in this fashion can really only be a general guide, as it is quite possible to mix a warm blue or a cold greenish yellow. Similarly, a fiery red will rapidly cool with the addition of violet.

The advancing and receding colors

One of the advantages that full-color work has over the drawn line is that the illusion of space can be rendered much more effectively. A skillfully executed painting creates the impression of distance and brings the foreground convincingly close.

Linear perspective follows a strict discipline, the rules of which can be mastered with careful study. Unfortunately, this is not the case when working in color. In landscape work particularly, Nature makes the rules and seems to be constantly changing them; the relationships of one color to another depends on the prevailing light conditions.

We can however work within general guidelines: the colors that will appear to recede and give the impression of distance can be taken from the range of cool colors—blues, violets, dull browns, grays; colors which will appear to advance may be drawn from the warmer, brighter hues—yellows, oranges, reds.

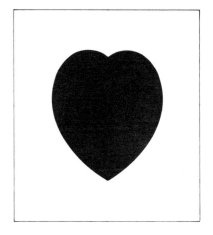

To demonstrate that brighter, and therefore lighter, colors will seem to be closer, compare the two shapes above by holding the book at arms length. Both are the same size, but the white shape will appear to

be larger. Let us now compare a light and dark *colored* area.

Again, the area containing the most light, the yellow, will appear larger and closer than the darker blue shape.

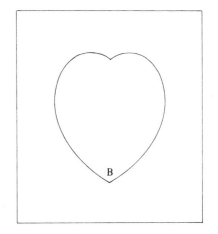

Paint the circles in a variety of colors of your own choosing; some light in value, others dark.

We will now compare the relative "sizes" of a range of colors.

Stand back from the book and notice how the lighter colors appear to advance leaving the duller hues behind. We must be careful, however, not to rely too much on this guide, as a pure, bright blue or green will often give the effect of greater proximity than a dull, impure red or yellow.

Nature provides us with many examples of color perspective. As the distance increases, the colors of a range of tree-covered hills will change from green in the foreground to yellowish-green, turquoise, and finally blue. Look out to sea on a clear day and you will observe that it, too, becomes bluer close to the horizon.

Bare, gray mountains are often mistakenly painted progressively bluer as they recede, whereas, in fact, their gray lightens in tone with distance. Dull brown hills will gradually turn mauve as they recede. The advancing colors, yellows, oranges, and reds, hardly change with distance. Yellow, which is the most reflective of hues, will tend to lighten slightly.

The secret of creating distance with color is to observe Nature constantly and make note of the variety of ways in which she will treat the same subject according to the available light. These constantly changing effects were significant enough to take the Impressionists, those great recorders of color, from their studios into the great outdoors. Their loss of comfort was more than repaid by the results they achieved working directly with Nature, with as few preconceived ideas of what to expect as possible.

Color memory

When it comes to remembering colors we are all poorly equipped. Our minds are lazy and take a shortcut. To save the effort of accurately processing the constantly changing data received from colored objects, the brain registers the color it decides is the norm. Unless called upon for extra concentration the mind sees an object as the color that experience has associated with it: leaves are green, the sky is blue, shadows are gray, etc.

To illustrate this, think of the last time you tried to remember a particular hue, maybe when buying paint to redecorate a room in which you had spent a great many hours. Without taking along a sample, you would be more than lucky to come away with anywhere near the correct color.

As an experiment, paint two paper shapes, one of a tree trunk and the other of a leaf, the same brownish green. Shown separately, almost certainly the tree trunk will be identified as brown and the leaf as green.

I have included this section to point out the great danger of seeing color without really looking. If you wish your work to have a natural appearance you will, just as the Impressionists did, have to train yourself to see the color that is all about us, but seldom registered. It will be a difficult task.

To help with accurate color perception, try isolating a small area, by looking through a tube or a hole in a card. This will help you particularly to see the colors in shadows and reflective surfaces.

Color from black and white

Between the black lines, a sensation of flickering pastel colors is formed. Almost any pattern having black and white lines or dots present in near equal amounts, gives this effect. Pop artists have made very attractive use of this phenomenon. It is not fully understood why it occurs.

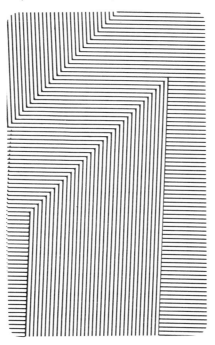

The psychological effects of color

Generally speaking, color has to cover a fairly large area to invoke our feelings strongly one way or the other. Nevertheless, a painting that is executed mainly in blues and greens will have less of an immediate impact and convey quite a different mood than one composed of reds and oranges.

We all respond to color differently; a pink that some enjoy will be intensely irritating to others (possibly because it is a color that is neither warm nor cool). Another hue that many find rather unsettling is violet; its makeup of blue and red causes conflict in the mind. Does one respond to its aggressive red content or its quieter soothing blue?

Red has a very direct impact on the emotions. Most people in a room painted red tend to become argumentative. Red objects appear closer and spaces smaller; it is exciting to some and oppressive to others.

Orange is a color that most of us seem to find quite acceptable. It is expansive, outgoing, and warm. Yellow, too, causes few upsets; it is brighter, cheerful, and totally unrestrained.

Although green can usually be taken as being a very soothing color, certain brighter shades can bring about a feeling of nausea in many people. Reliable, calming, cool blue gives many a feeling of security and tranquility. Brown is usually thought of as being practical and easy to live with.

Color can even affect our perception of weight; objects painted in the darker, receding colors actually seem heavier to lift than when painted white or yellow.

The perception of time can also be influenced. In a room illuminated by red light, an hour will seem to pass by quicker than one spent in a room with a green or blue light.

The influence of color on our emotions and moods is so variable from person to person that no hard and fast rules can be laid down. I have included this very brief outline of the effects of color on the mind to illustrate the fact that, as we all see color differently, so we all react to it differently.